Color Test Page

Color Test Page

BONUS

Get 4 pages fom this book in PDF for free at
4freedesigns.gr8.com

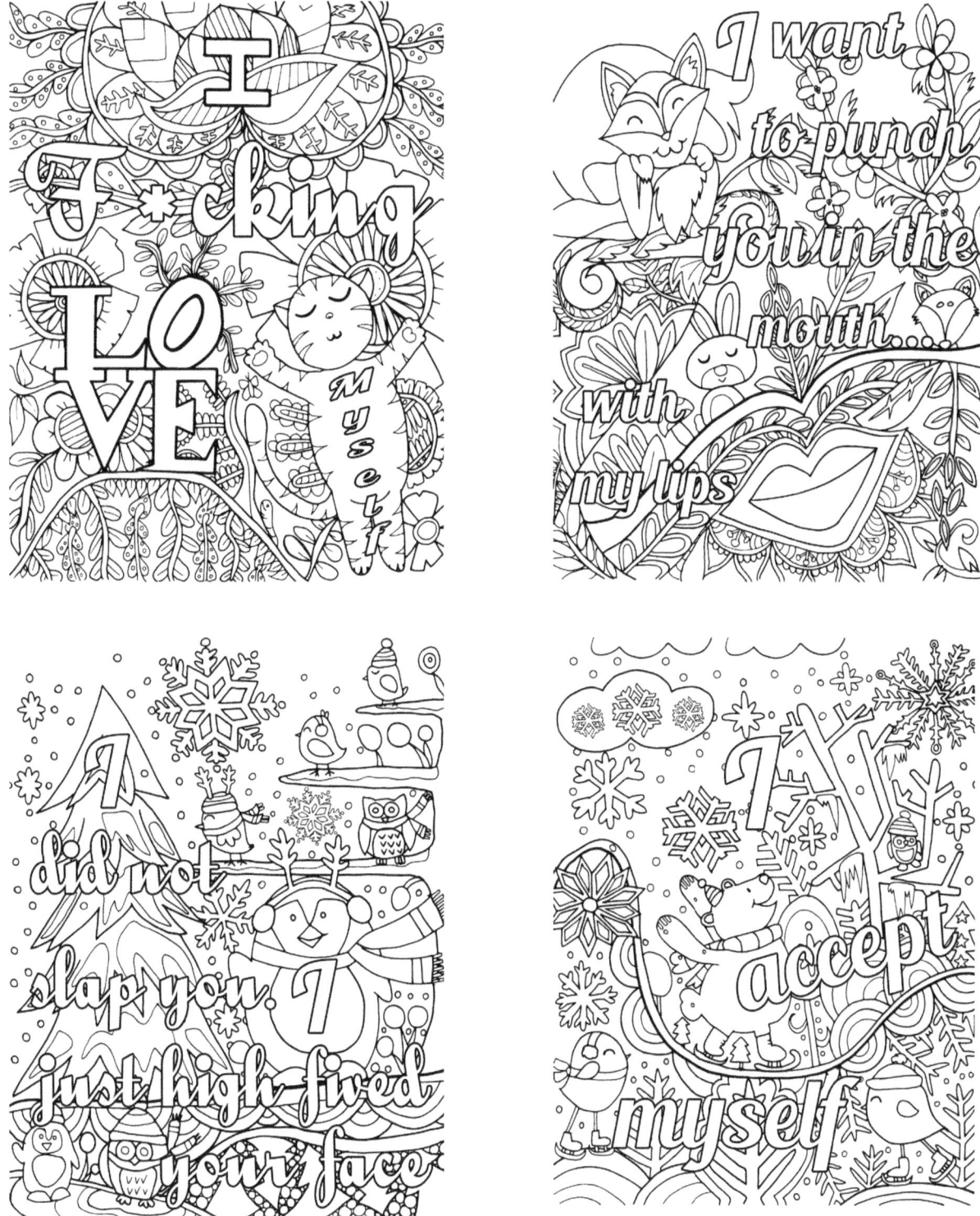

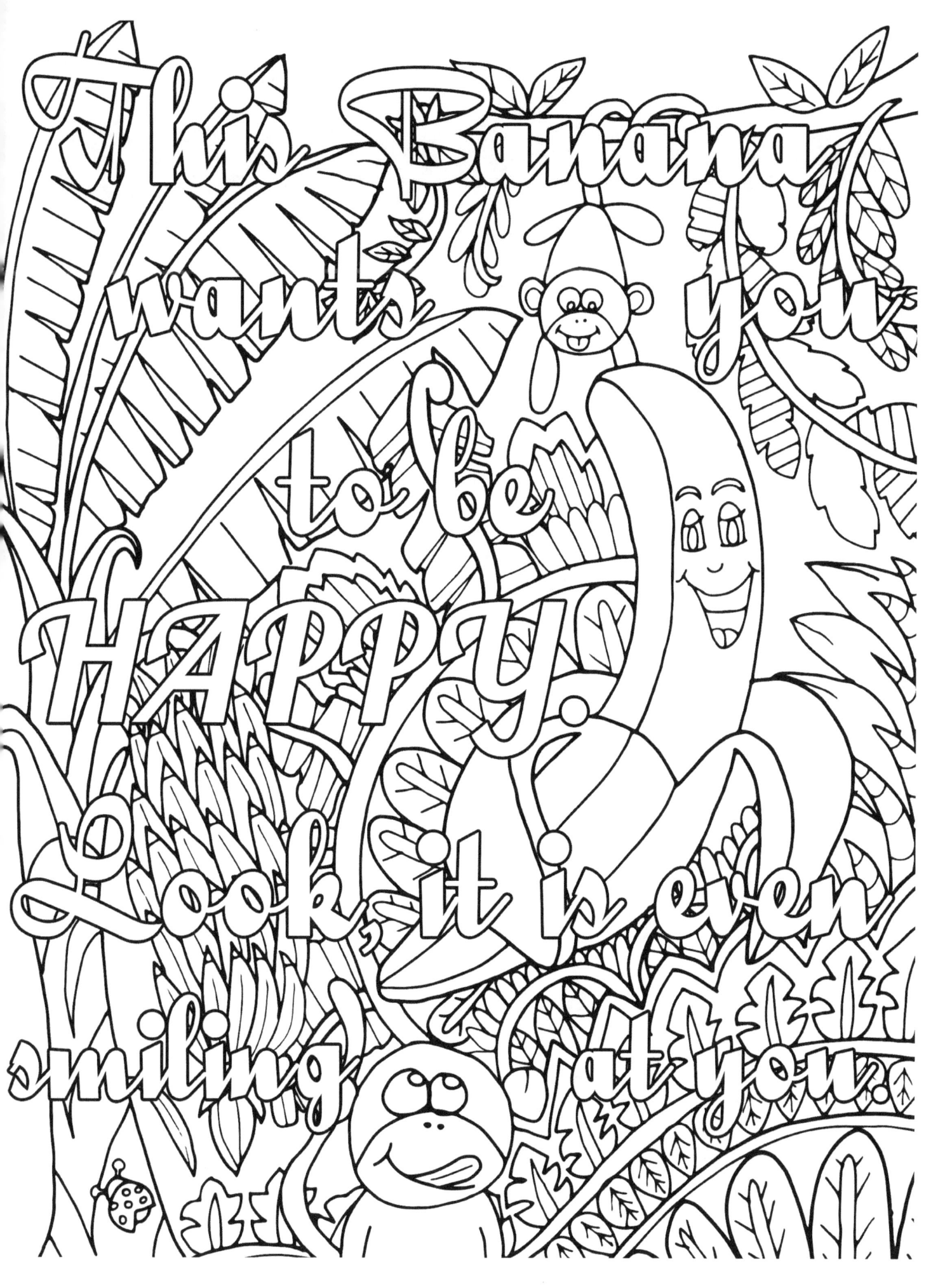

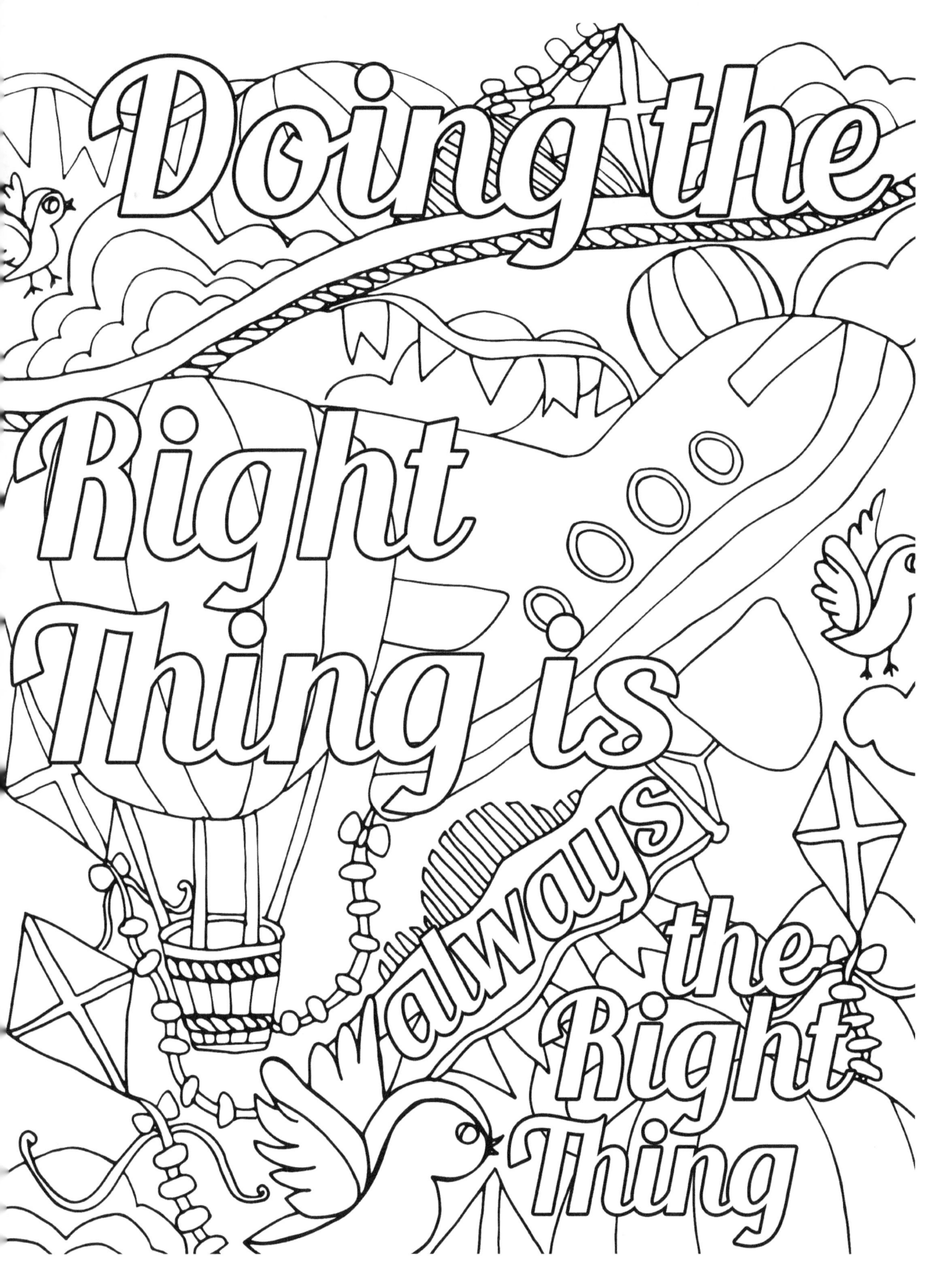

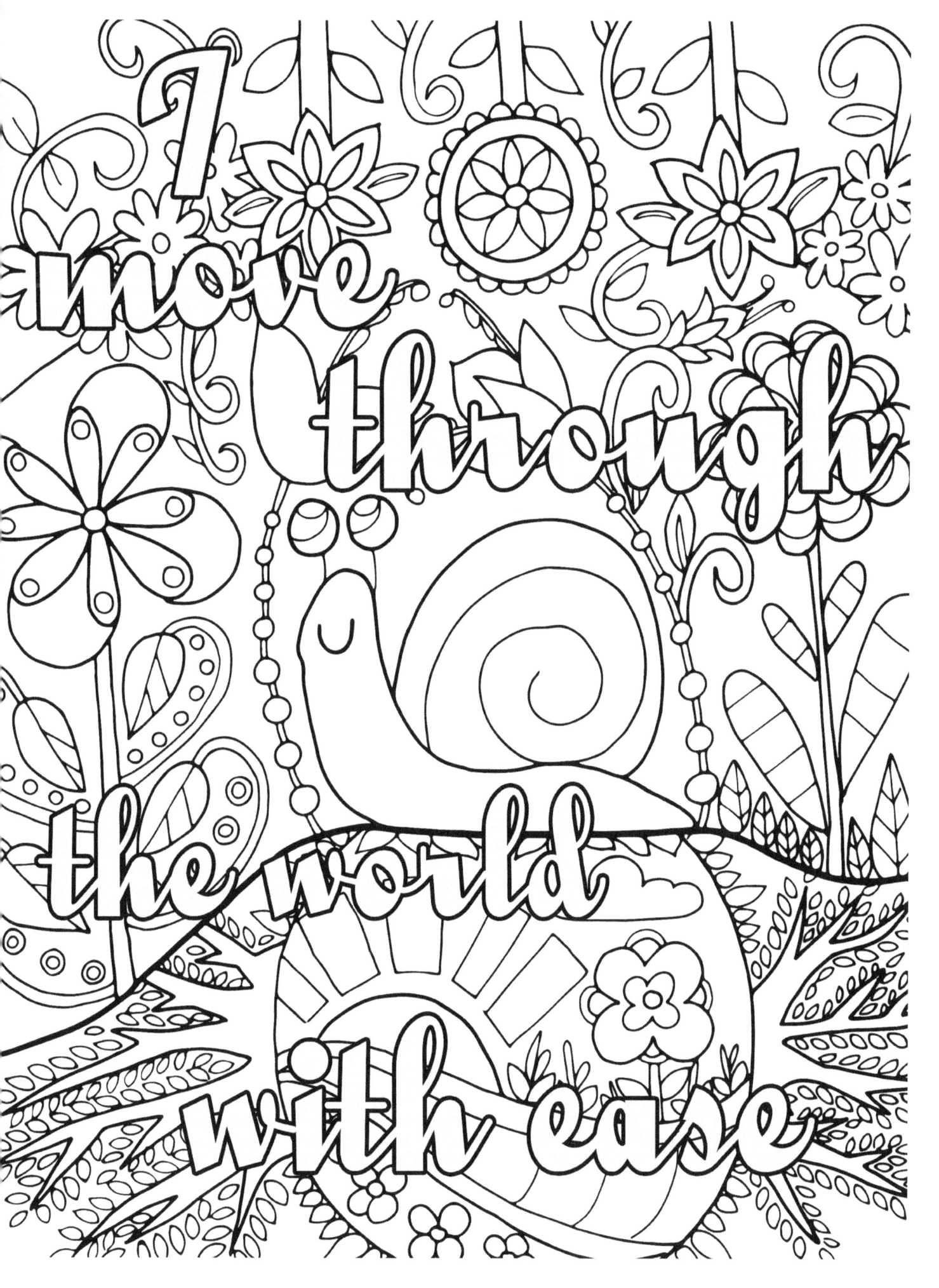

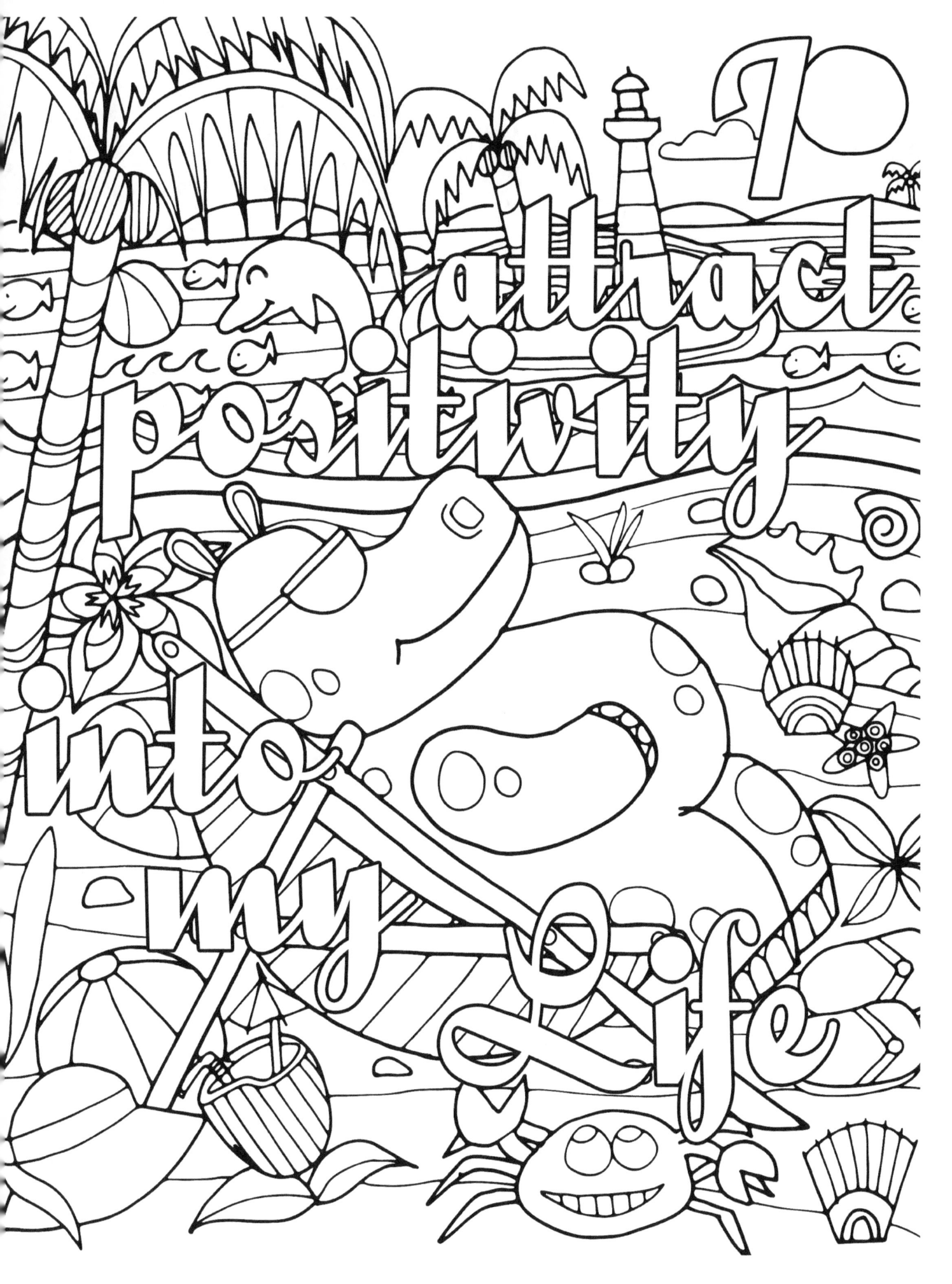

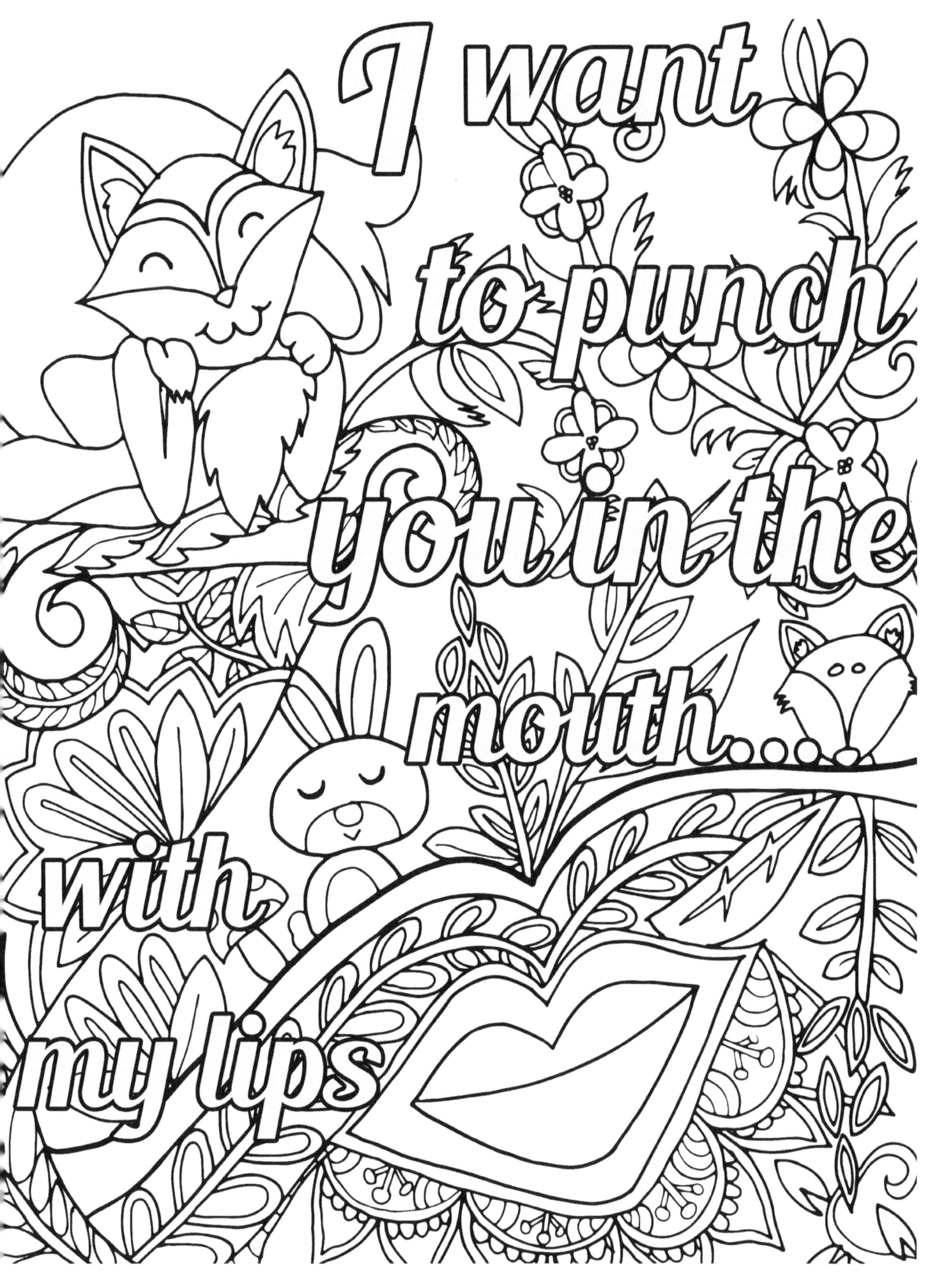

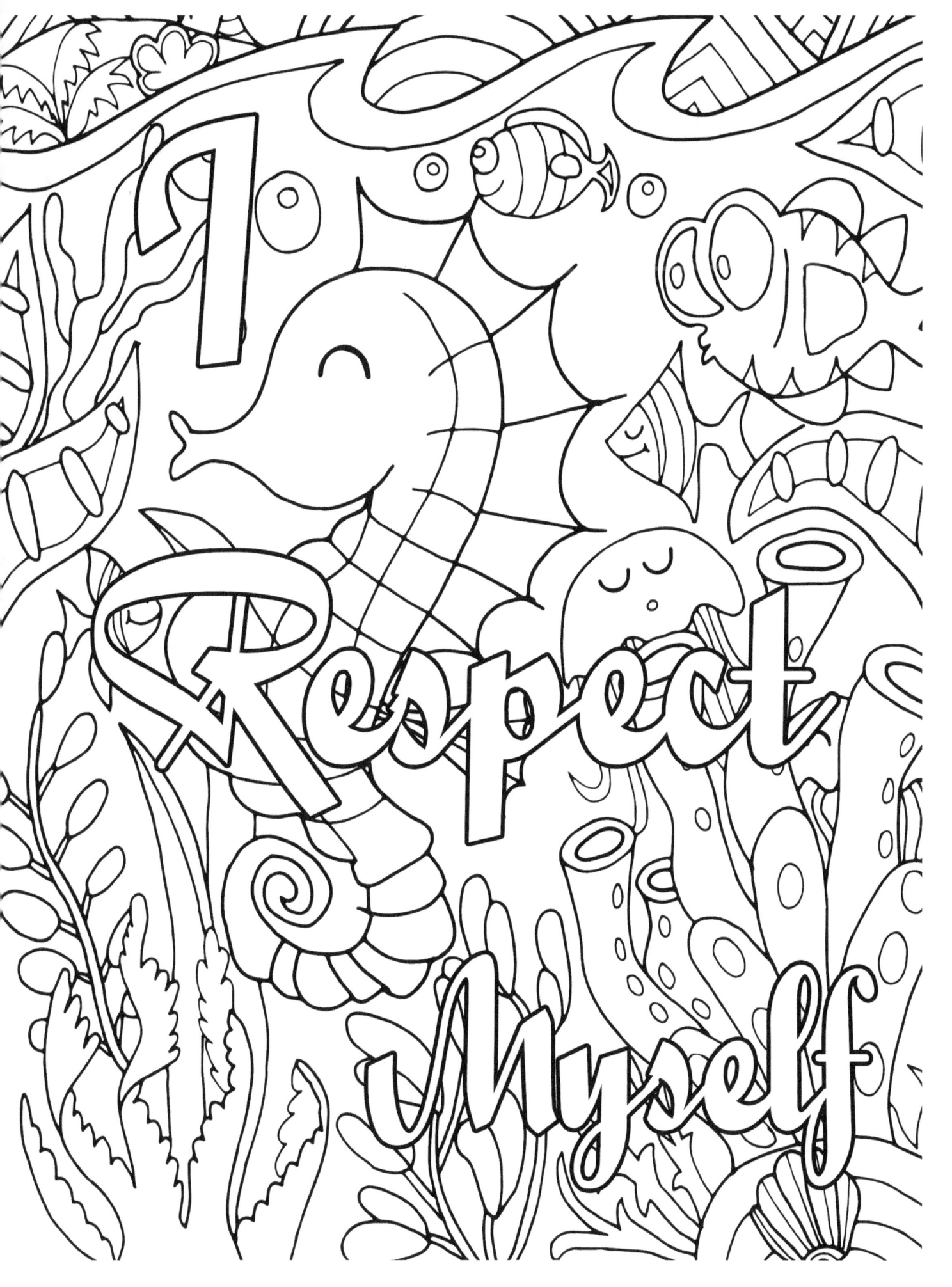

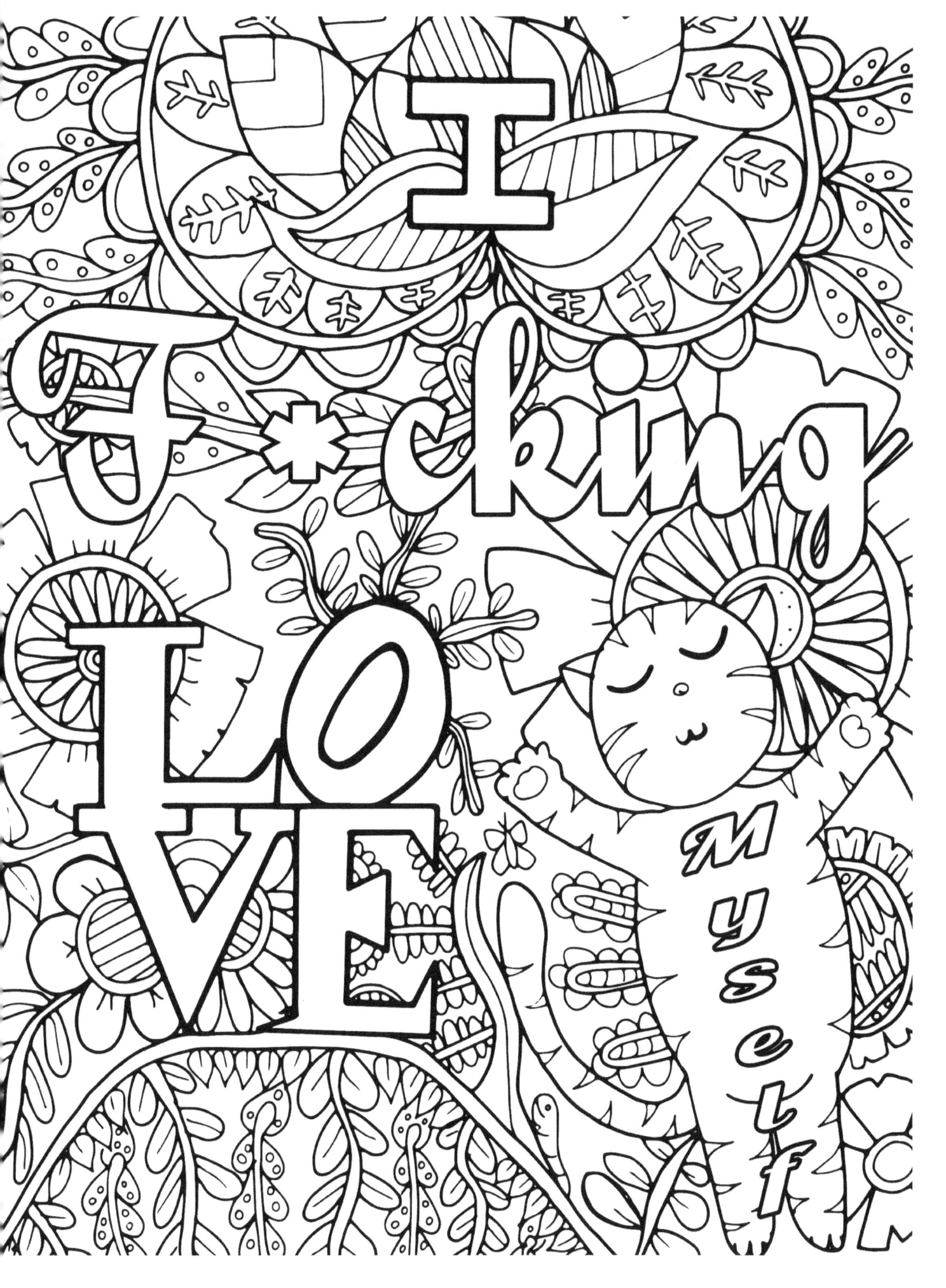

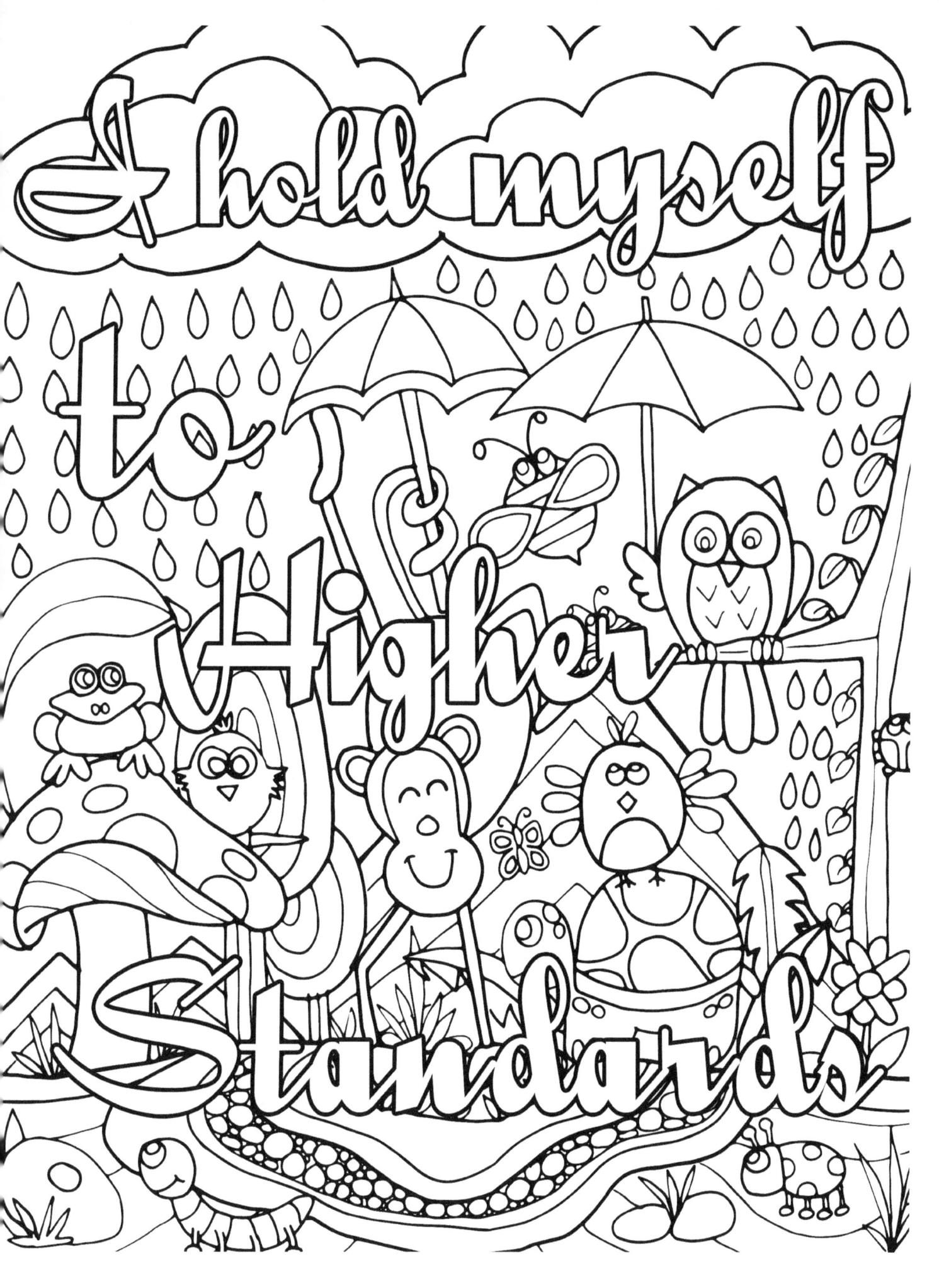

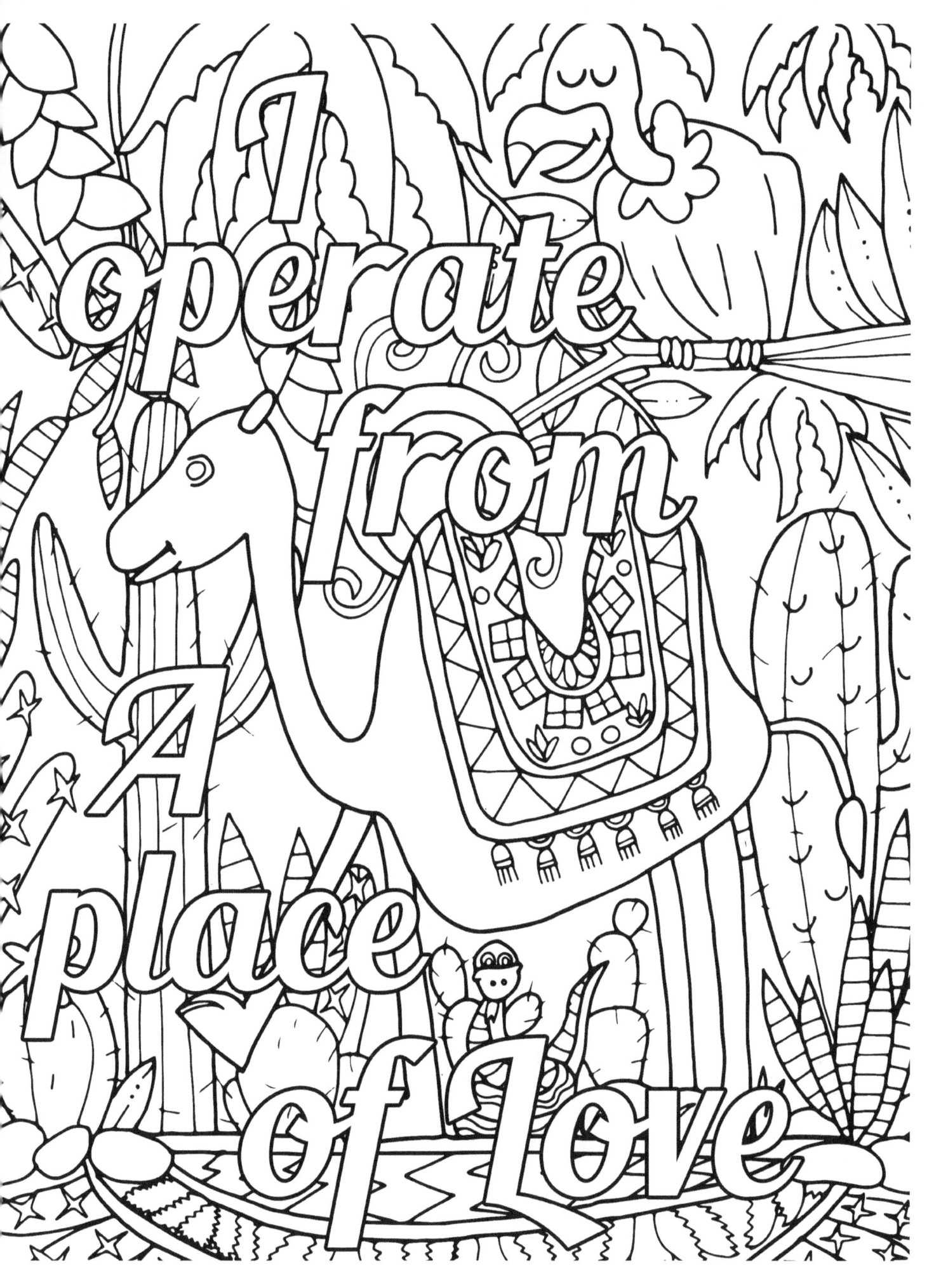

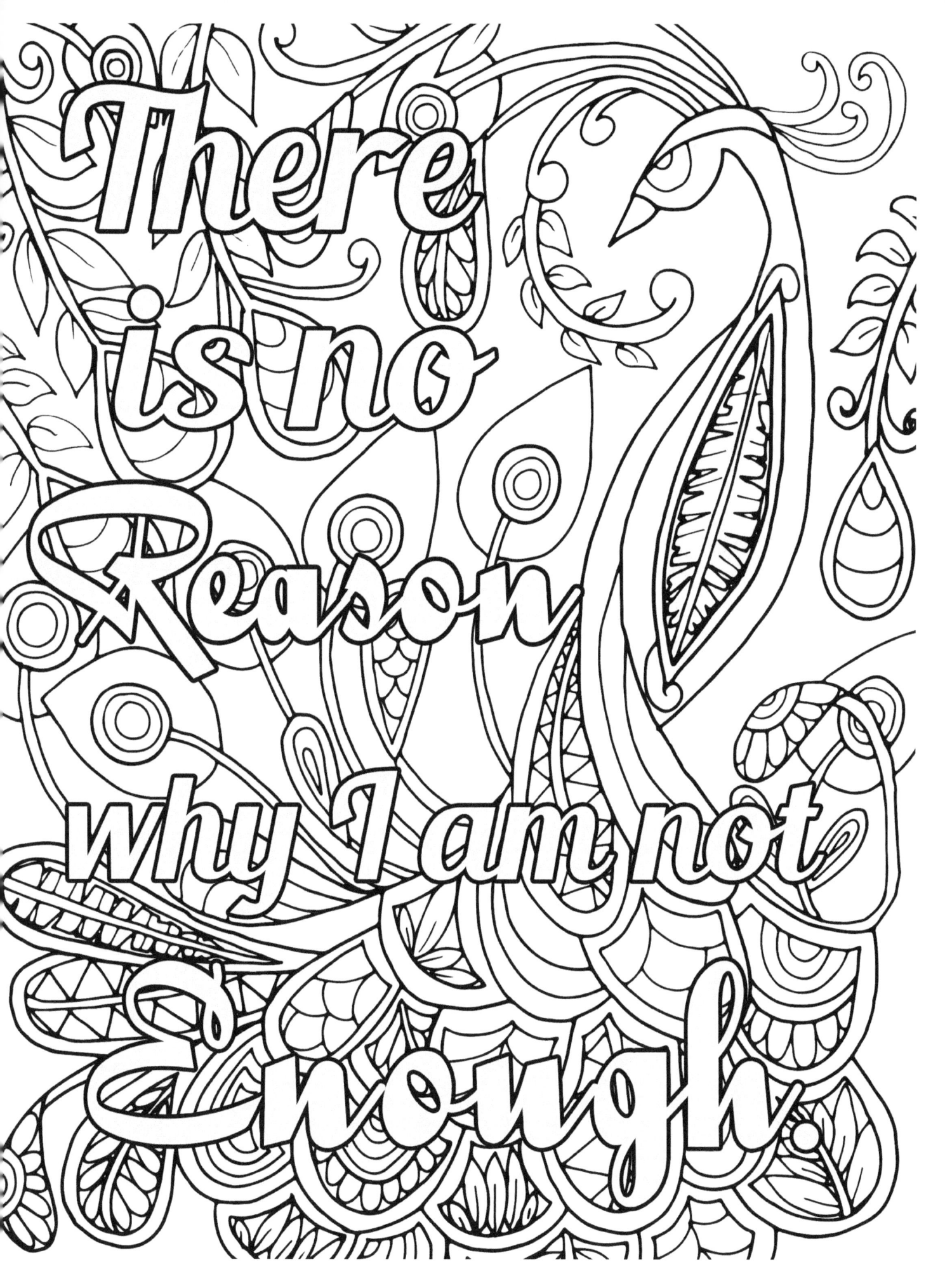

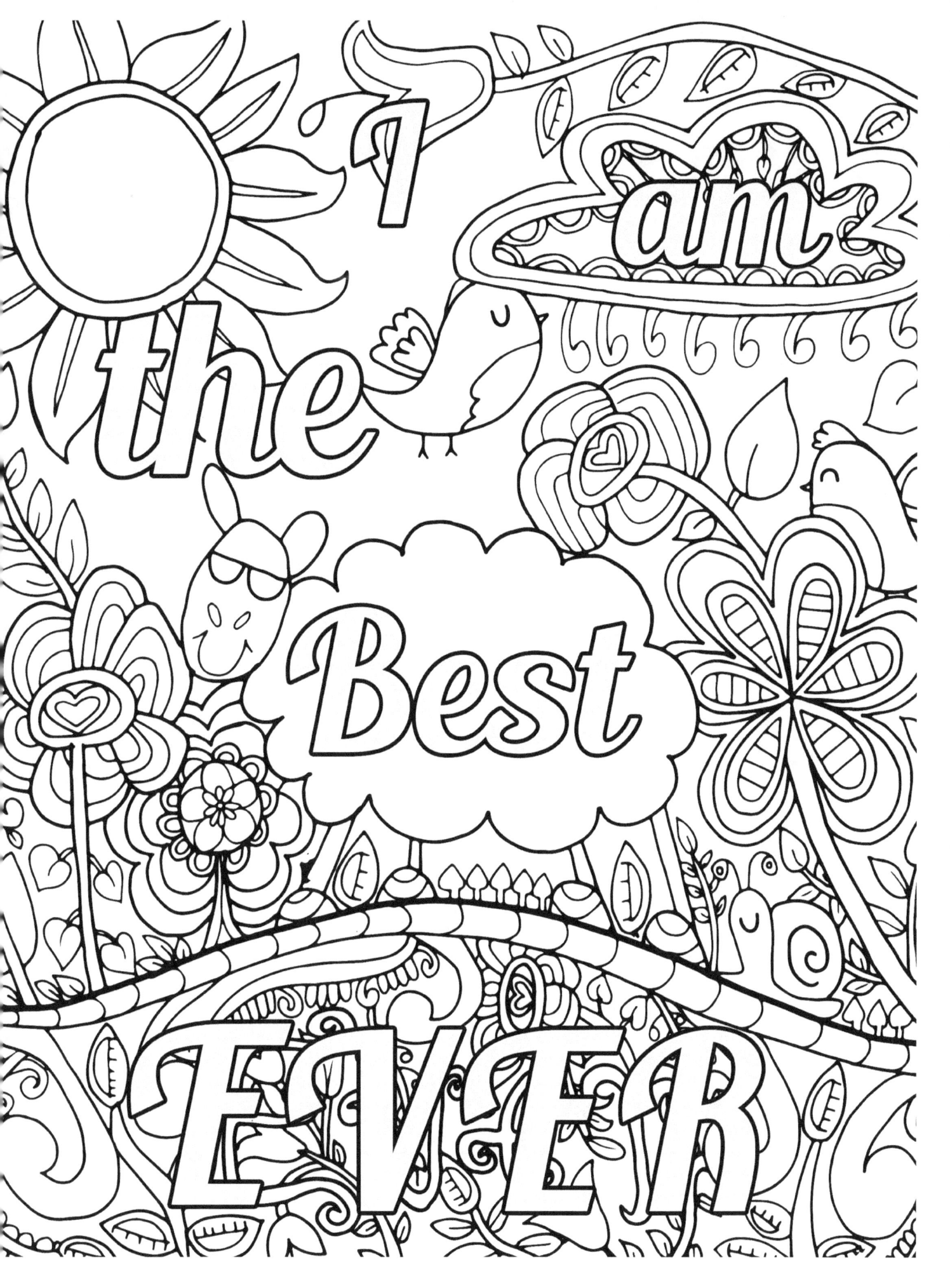

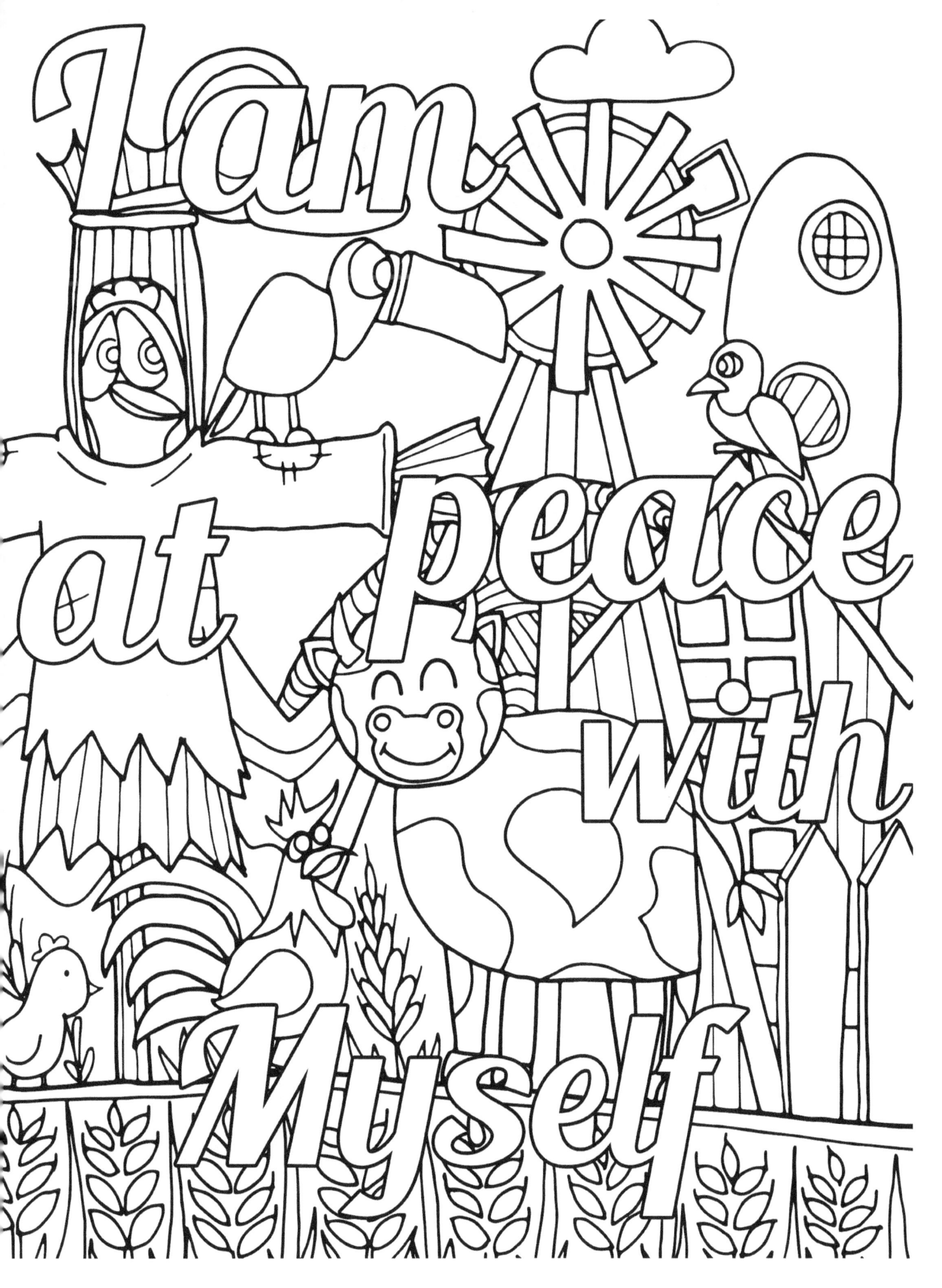

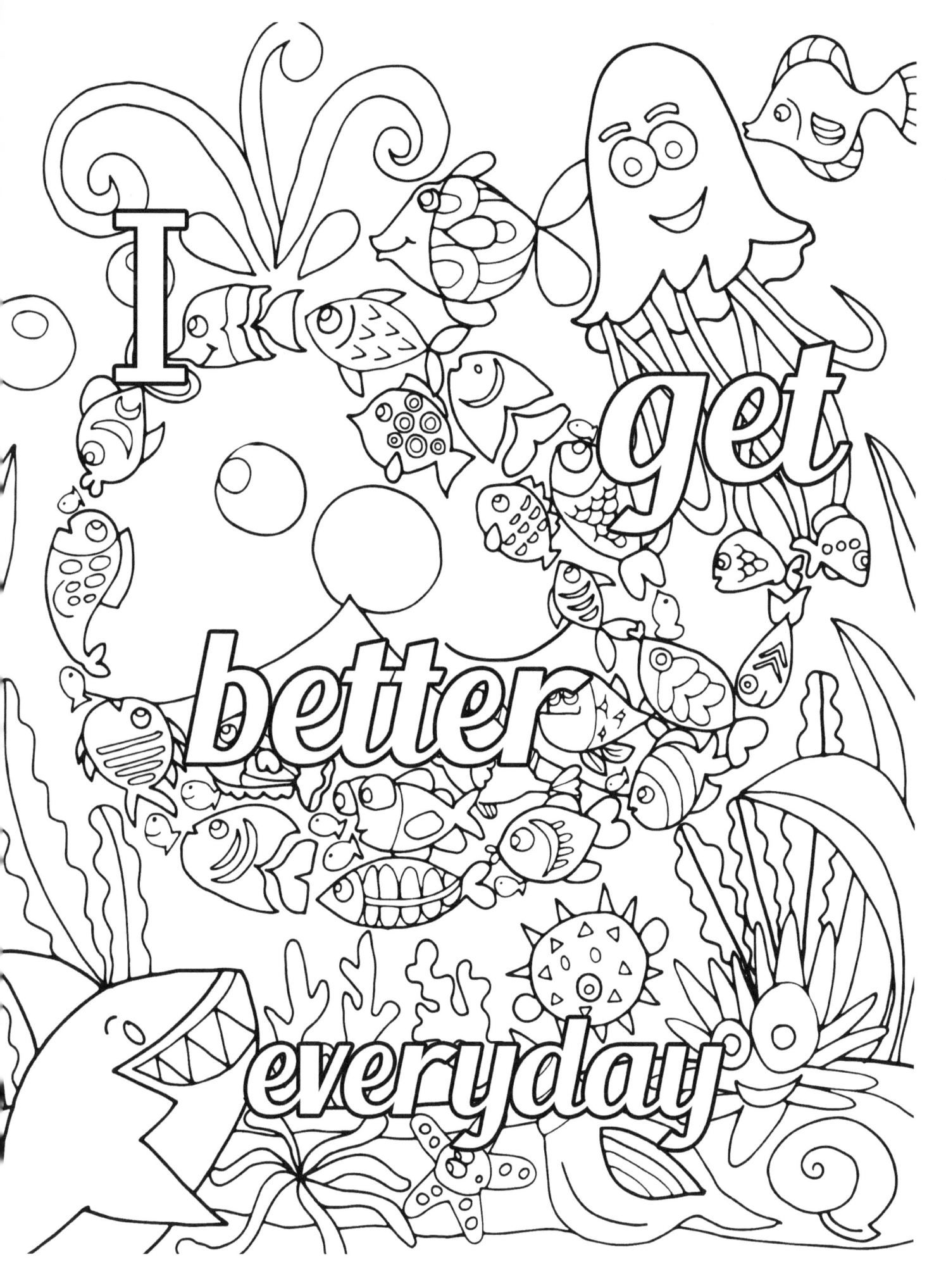

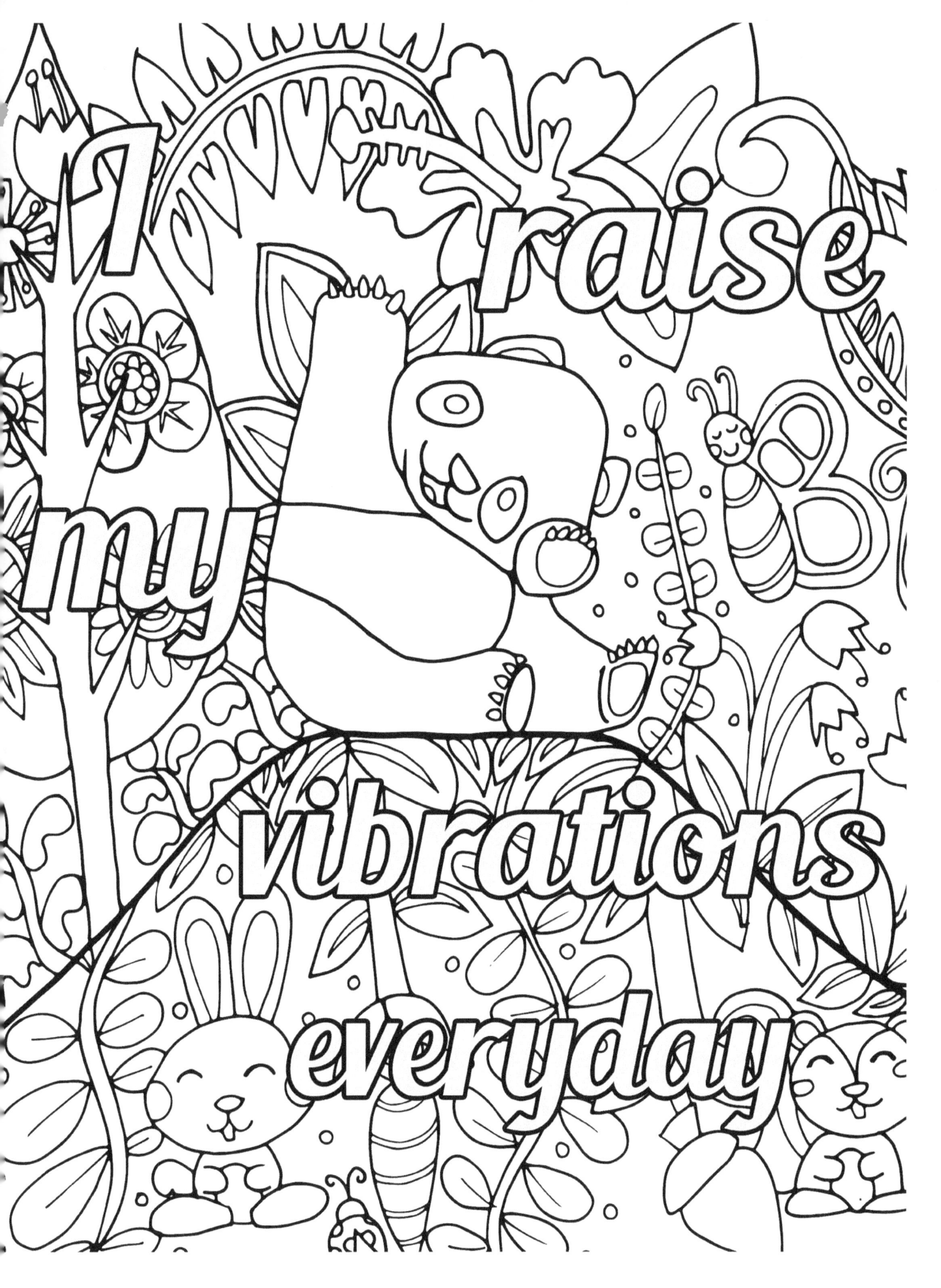

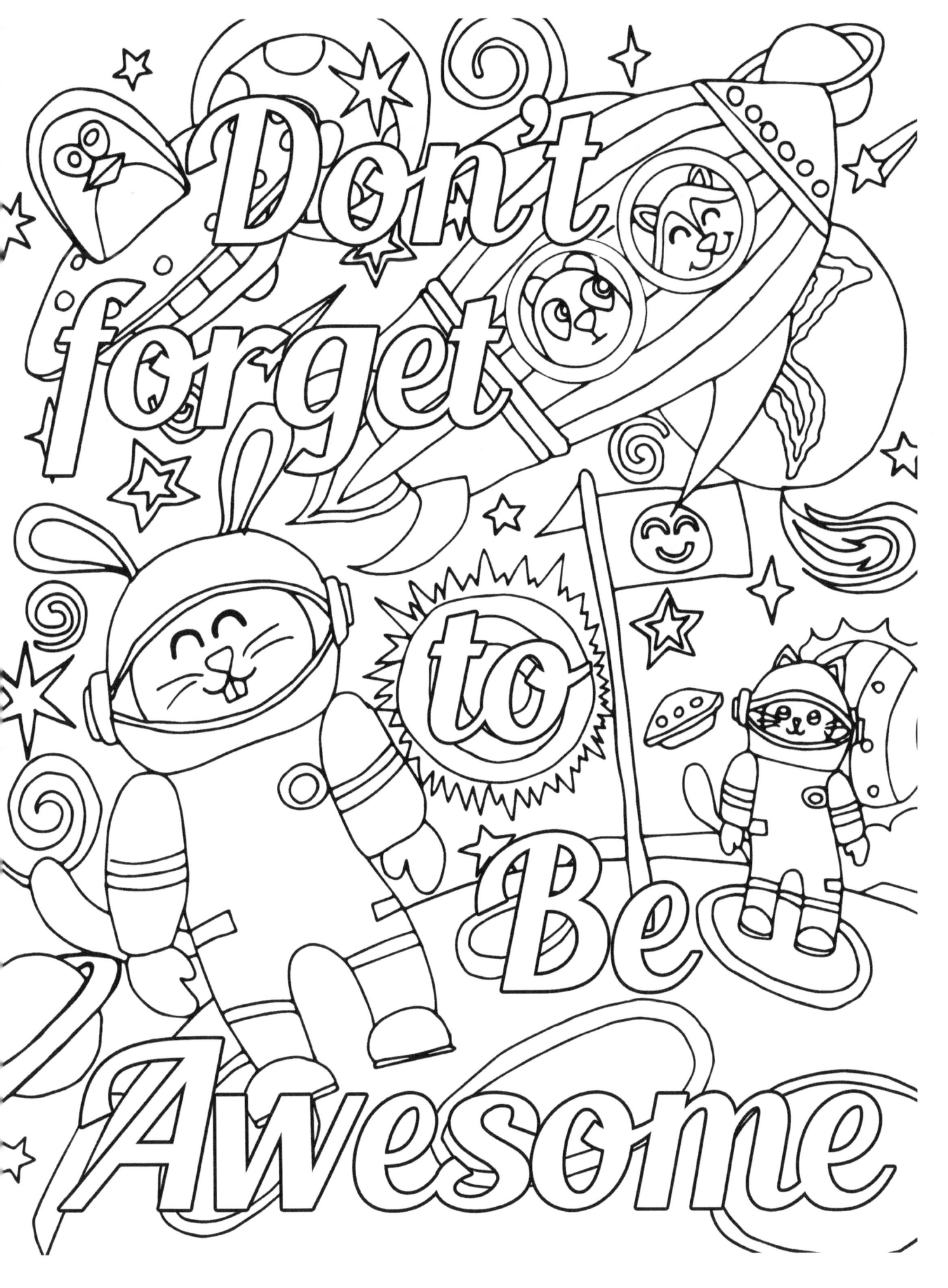

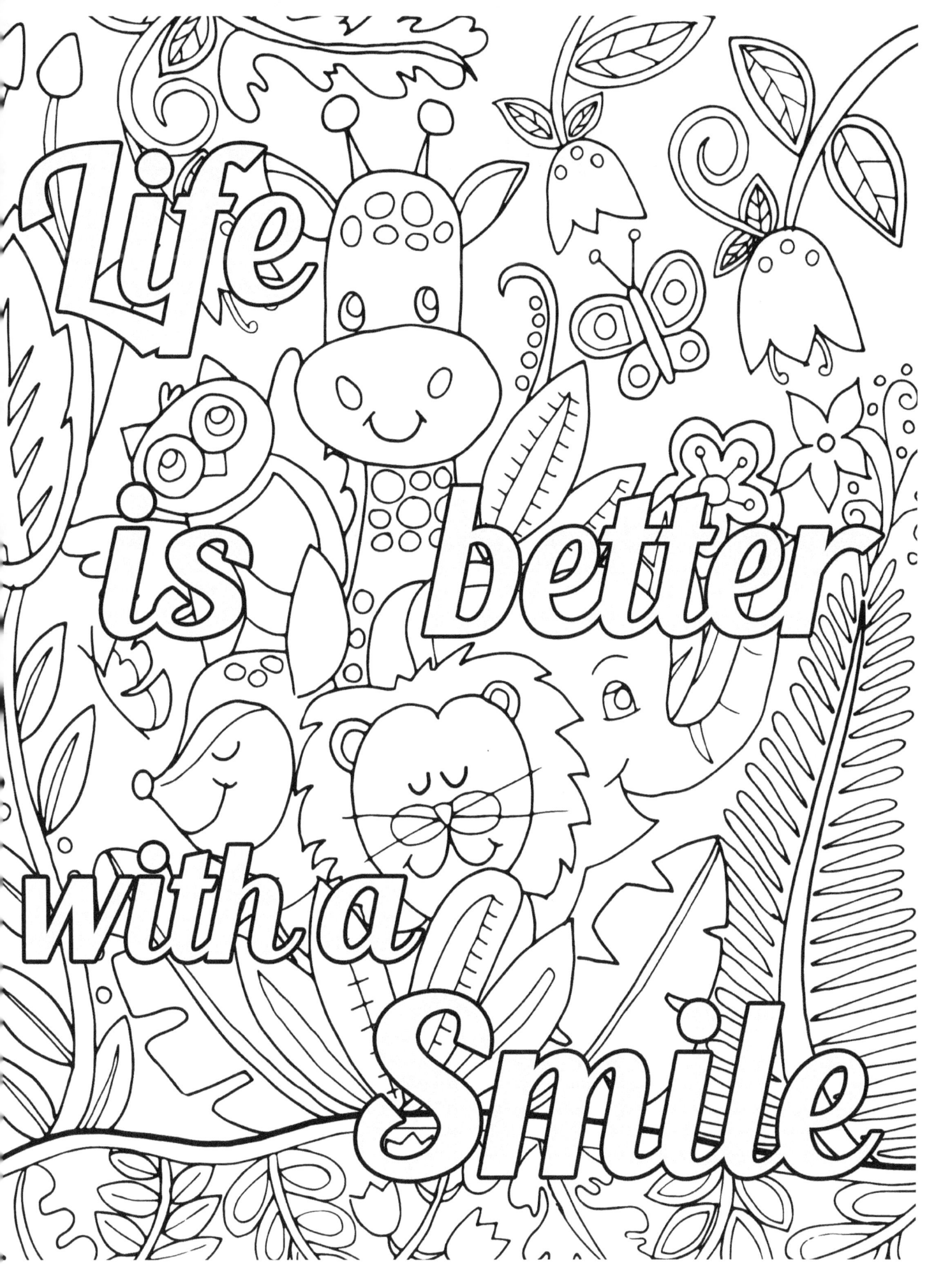

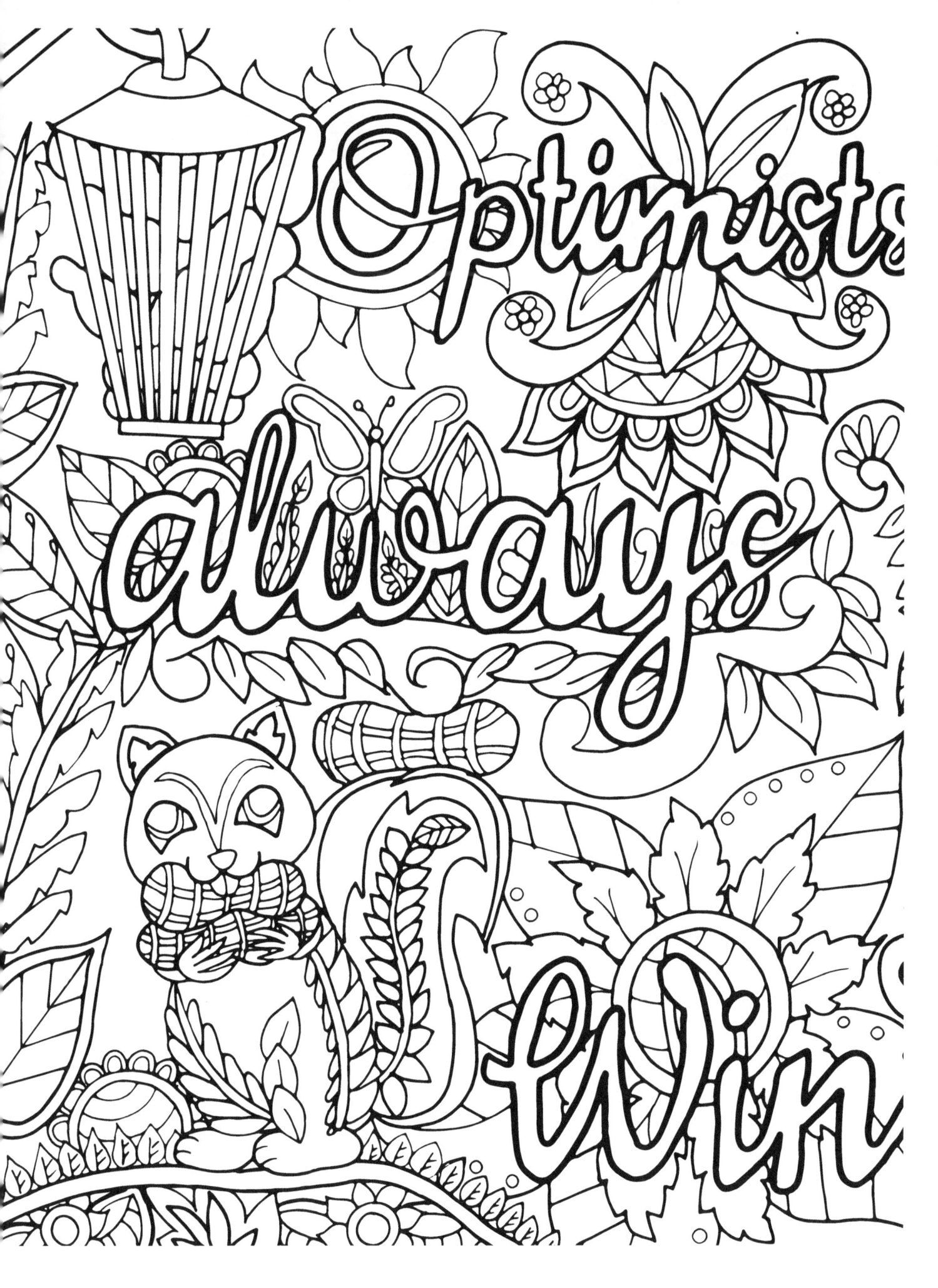

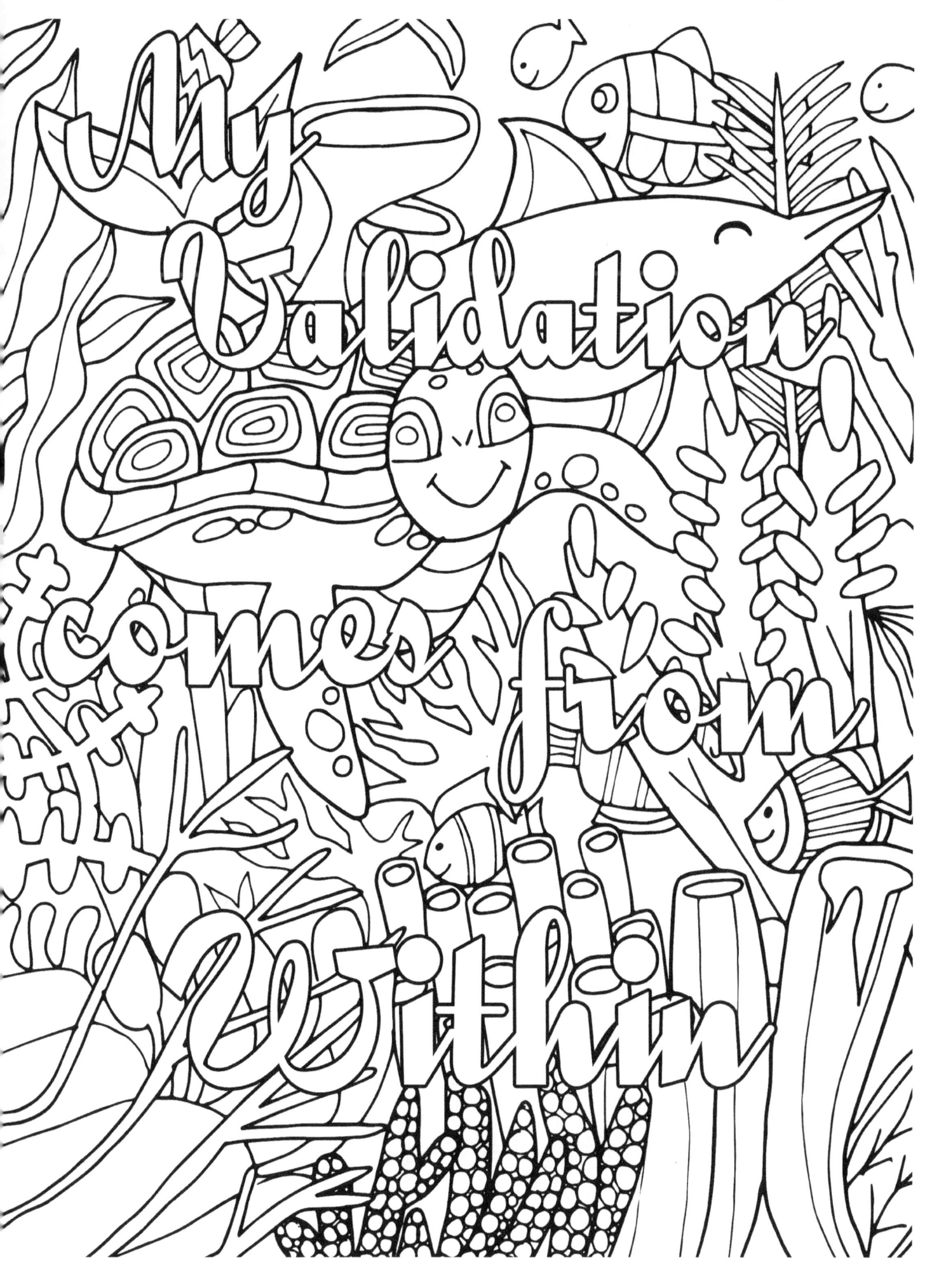

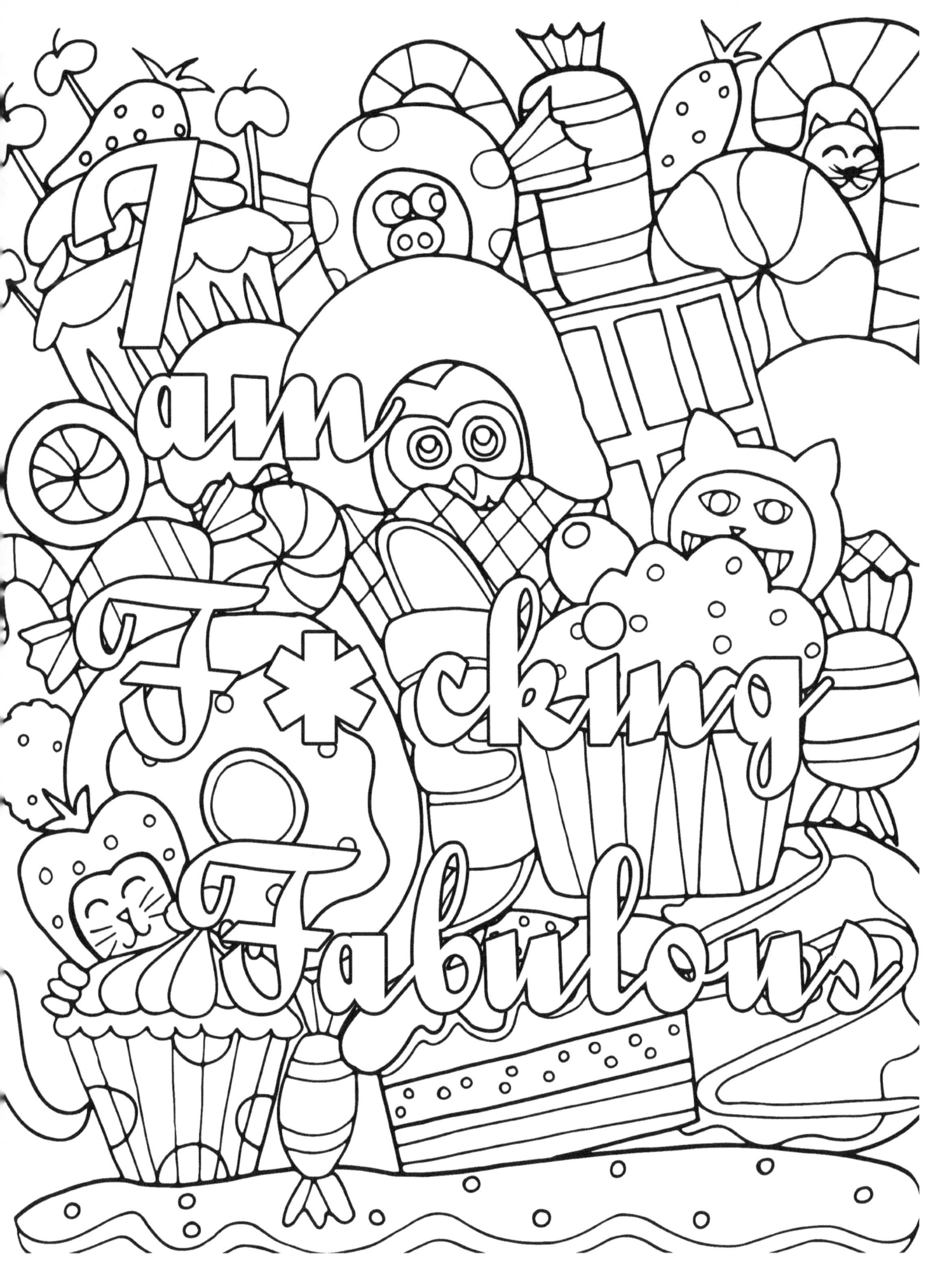

www.ingramcontent.com/pod-product-compliance
Lightning Source LLC
Chambersburg PA
CBHW080558190526

45169CB00007B/2816